D0524455

ARTIST'S
WORK
BOOK

The Practical Guide to

DRAWING
LANDSCAPES

ARTIST'S
WORK
BOOK

The Practical Guide to
DRAWING
LANDSCAPES

PETER GRAY

ARCTURUS

ARCTURUS

This edition published in 2013 for Index Books

Text and illustrations copyright © 2009 Peter Gray
Design copyright © 2009 Arcturus Publishing Limited

All rights reserved. No part of this publication may be reproduced,
stored in a retrieval system, or transmitted, in any form or by any
means, electronic, mechanical, photocopying, recording or otherwise,
without written permission in accordance with the provisions of the
Copyright Act 1956 (as amended). Any person or persons who do
any unauthorised act in relation to this publication may be liable to
criminal prosecution and civil claims for damages.

Series Editor: Ella Fern

ISBN: 978-1-84837-275-7
AD001170EN

Printed in China

CONTENTS

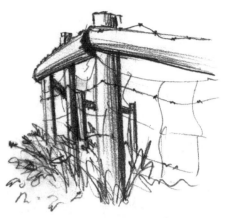

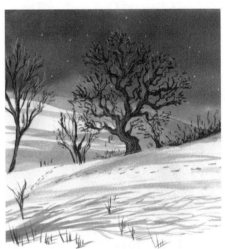

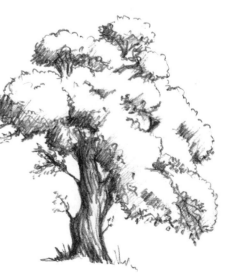

INTRODUCTION

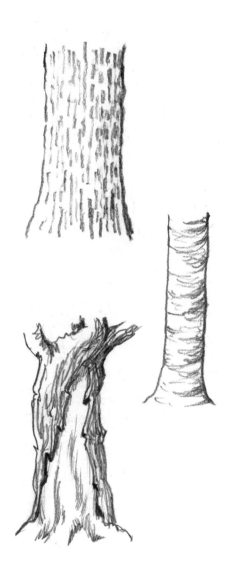

Whether you have access to coast or country, fields or forests, moors or mountains, you will never be short of subject matter; every landscape is worthy of your attention. With ever-changing skies and atmospheric conditions, even the most featureless wasteland provides rich pickings for the artistic eye.

Landscape differs from other areas of study in that the shapes and scenes are imprecise; if you draw a tree too large or small or position it in the wrong place, it will not detract from your artwork. This means that even the complete beginner should be able to draw with the boldness and confidence necessary for producing satisfying results.

This book aims to instruct the reader in the drawing skills that may be applied to any type of landscape. It is designed as a course, with each new subject following on from the previous one. Step-by-step demonstrations will teach you to capture basic natural form and then gradually increase your facilities to render shade, texture and detail.

Though some of the exercises may be undertaken indoors, the great pleasure of landscape drawing comes when you venture beyond the comfort of the home. Whenever possible, get out among the elements and work directly from nature. This book will discuss some simple practical measures you need to

Draw confident and economical marks with the simplest of tools.

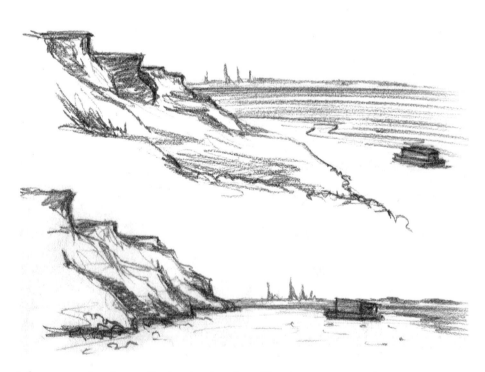

Inform your drawings with the simple rules of landscape perspective.

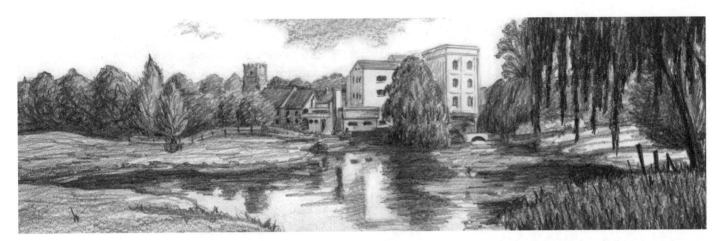

take for the sake of your drawings and your physical comfort. Outdoors, the practice of sketching comes into its own, as a means of gathering information and for developing your skills. Sketches done in the field can be developed into artwork at home, but portable materials are also perfectly sufficient for producing finished pieces on location.

We will investigate various materials and techniques and strive to develop your imaginative interpretation of natural scenes as well as your own expressive drawing style. It's down to you to decide what it is about a landscape that interests and inspires you, and with the lessons contained in this book, you'll be able to capture something of your delight on paper.

Develop your eye for selecting powerful compositions.

Learn to see the basic simplicity of tones and strive for boldness of execution.

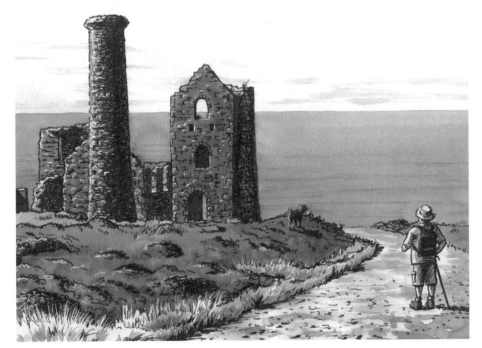

Expand your range of materials and methods to achieve accomplished results.

BASIC MATERIALS AND EQUIPMENT

One of the great things about taking up drawing is that you need very little equipment to get started. Some of the elaborate items on show in art shops can be very tempting, but fancy media and equipment generally do little to improve your skills and can confuse the issue of learning to draw. To start with you'll need pencils, paper, an eraser and a knife, but throughout the book we'll look at other materials and tools you might want to experiment with and add to your kit.

Pencils

Although any pencil will do for mastering the basics of drawing, cheap ones can be scratchy and unsatisfying to work with. It's well worth splashing out on a few good-quality pencils from an art supplies shop. They are graded from H (hard) to B (black) with a number prefix indicating the degree of hardness or blackness. A useful starting set would be H, HB, 2B and 6B.

HANDY HINT

Buy pencils of different grades in different colours so that you can identify them at a glance.

Sharpening

A sharp knife or scalpel is essential for fashioning the points of your pencils. For drawing the many textures of landscape, pencils are ideally sharpened to reveal a good length of lead, unlike the uniform point produced by a pencil sharpener. Keep the blade at an acute angle to the pencil, and always sharpen the pencil away from your body. Soft pencils such as 2B or 6B require regular sharpening, maybe several times in the course of a single picture. A pencil sharpener has its place, being more convenient for regularly reclaiming a point for detailed work. And if you're working in a litter-sensitive location, you can get sharpeners that are built into a capsule that collects the shavings.

Erasers

An eraser is a vital part of your kit. There's absolutely no shame in erasing mistakes and rough guidelines – they are essential to the drawing process.

Buy a good-quality eraser that is not too hard; there are many varieties on the market but they all do essentially the same job. For fiddly erasing, I often use a special eraser that comes in pencil form and can be sharpened to a point. When working in charcoal, a kneadable putty rubber allows you to lift off the pigment without smudging a delicate drawing.

HANDY HINT

When the corners wear blunt, an eraser can be trimmed with a knife to produce a fine working edge.

Paper

For general sketching in the field, a hard-backed, book-bound sketchbook, A4 (21cm x 30cm / 8 x 12in) or A3 (42cm x 60cm / 16½ x 23½in), is invaluable. Opening to two opposing pages, such books offer the overflow space for supplementary sketches and notes with both pages being amply supported. A cheap one would be best to start with because it's important that you don't feel too precious about it. Expensive paper only serves to inhibit your freedom to make those all-important mistakes.

As you advance in skill and ambition, the more important the grade and type of paper becomes. Chalks and charcoal work best on a lightly textured surface and some subjects might call for toned or coloured paper. Wet media, such as watercolour, need thicker paper that won't buckle with moisture. Paper rated anywhere between 200g/m² (120lbs) and 300g/m² (180lbs) should be quite stiff enough. You may also enjoy experimenting with shiny paper, brown parcel paper or even cardboard.

Drawing Board

More advanced papers are best bought as loose sheets, for which a small drawing board will be needed. Bespoke drawing boards are usually heavy and cumbersome, but a thin sheet of plywood, say 5mm (¼in), will be strong, yet light enough to carry with you for working on location. Make sure it is sanded smooth and larger than your paper, which can be affixed with masking tape at the corners.

HANDY HINT
Rubber bands stretched around an open sketchbook will prevent the pages flapping in the breeze.

MARK MAKING

Landscape, probably more than any other discipline, relies on the weight and style of marks that are used to describe the elements of a picture. Hills, mountains, clouds, trees, bushes, grass and earth – the forms and surfaces of landscape have indefinite shapes that require the appropriate textural marks to differentiate them. In the humble pencil, we have a tool that is capable of an unrivalled range of marks dependent on how it is held, the nature of the hand movement and the pressure applied.

Here are a few of the ways a pencil might be held for different drawing techniques and effects.

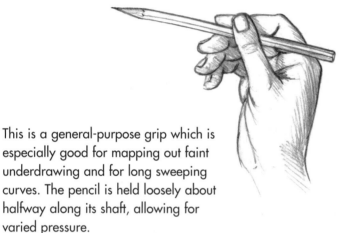

This is a general-purpose grip which is especially good for mapping out faint underdrawing and for long sweeping curves. The pencil is held loosely about halfway along its shaft, allowing for varied pressure.

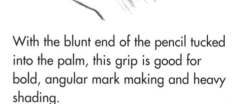

With the blunt end of the pencil tucked into the palm, this grip is good for bold, angular mark making and heavy shading.

Much like a typical writing grip but with the pencil more upright, this grip is good for fine detailed work or for drawing in a small sketchbook.

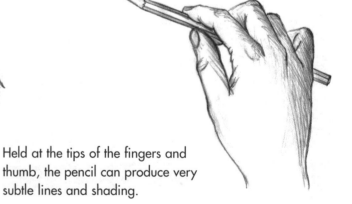

Held at the tips of the fingers and thumb, the pencil can produce very subtle lines and shading.

Whereas holding a pencil in your writing grip allows you control of small movements from the fingers, for drawing, most movements will be made from the wrist, elbow and shoulder. Different grips will free your pencil to make a full range of strokes, with that all-important element of confidence.

By merely changing the angle at which the pencil is held, the breadth and softness of the line changes dramatically. These marks were all made with the same soft pencil (8B), the first three of uniform pressure and the last with considerably less.

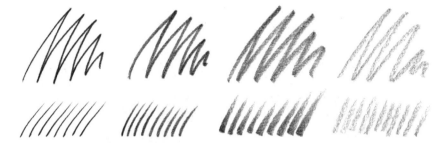

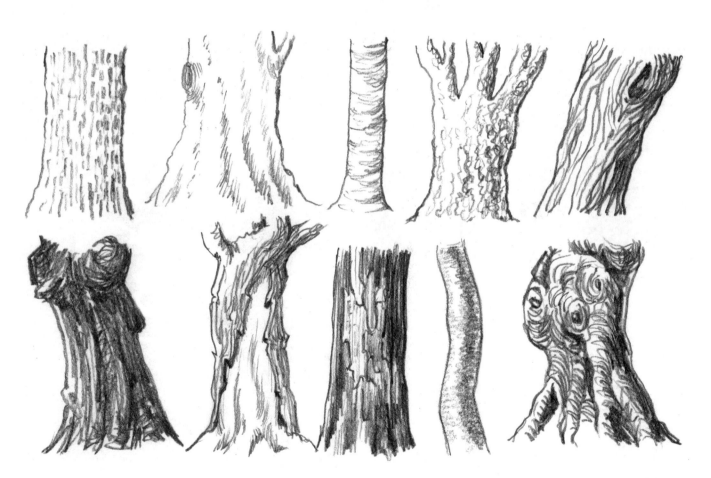

These examples demonstrate just a few of the different ways that sympathetic mark making can describe the texture and character of individual trees. I used the same pencil (4B) for all of these.

TREE FORMS

Proficiency in landscape drawing requires familiarity with the shapes, or 'forms', that recur in nature and how they are constructed. Mastering natural form is quite easy, but it takes careful observation to capture the subtle differences between similar landscape features. One of the most common landscape motifs, trees offer interesting challenges and variations.

Some trees are quite uniform and symmetrical, following basically geometric shapes. Typically, however, they are more idiosyncratic, identifiable by species, but no two the same. As these silhouettes show, they are not solid objects, but composed of distinct parts that combine to form masses. The spaces in between these masses allow light to pass through.

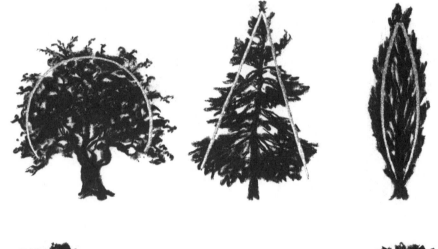

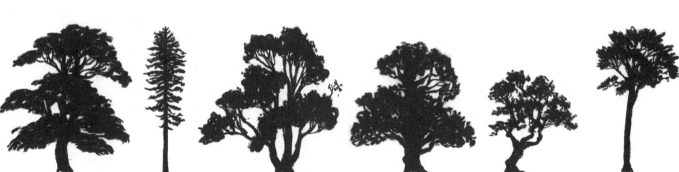

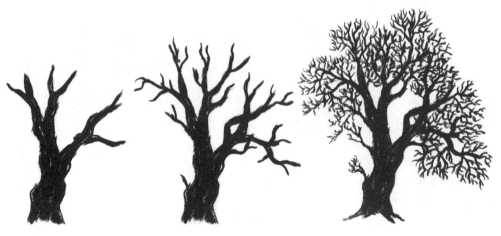

The best way to understand how trees are constructed is to start with the silhouette of a generic winter tree, with no leaves to hide the structure. The trunk is clearly the main solid chunk of a tree, from which grow a few heavy branches, or limbs, which sprout smaller branches. And so it goes out to the bustling network of tiny twigs, from which the leaves grow in the spring.

12

Step 1

To draw the real thing, quickly sketch the trunk and the general masses of foliage.

Step 2

Look more carefully at the form and refine the detail and silhouette. Note any visible bits of branch.

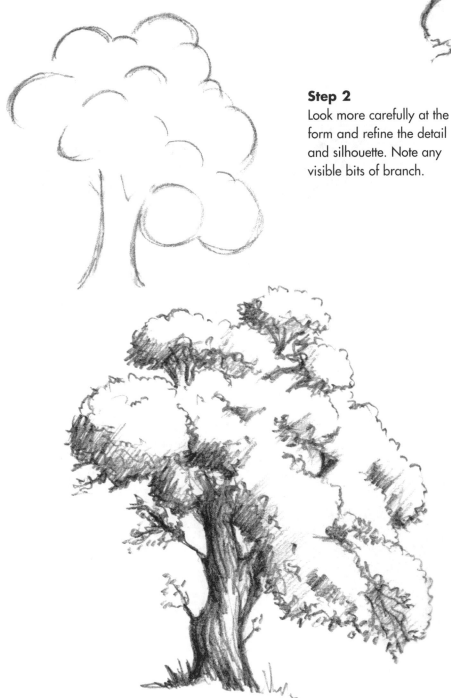

HANDY HINT

Think of the tree as a series of spheres supported by a number of cylinders. Mentally simplifying the form makes the job of drawing the foliage less daunting.

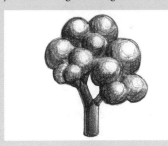

Step 3

Using the side of the pencil, shade the trunk and the underside of the masses of foliage to describe the tree as a three-dimensional form. It's often best to leave plenty of bare white paper, otherwise sketches can quickly become muddy and confused.

TONE AND MODELLING

As light falls on landscape features it illuminates some parts and casts others into shade, throwing a scene into relief. In capturing the interplay of light and dark, or 'tone', you create the illusion of three-dimensionality on the flat surface of the paper. Tone also brings clarity and it's important in establishing atmosphere.

Without tone, this apple is flat and the drawing seems more like a symbol than a representation of reality.

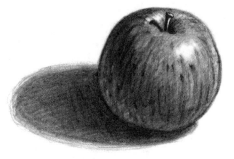

When tone is applied, we can see the apple's solidity and roundness and appreciate the brightness and direction of the light. The apple's underside is faintly illuminated by the 'reflected light' bouncing off the surface upon which it rests.

In this version, I've also shaded the apple's markings and 'local tone', that is, its inherent tonal value. This allows me also to show the 'highlights' on the surface, which convey the shininess of the skin.

ATMOSPHERE

Tone can be very effective in establishing atmosphere. These two sketches, showing different lighting conditions, are quite different in mood.

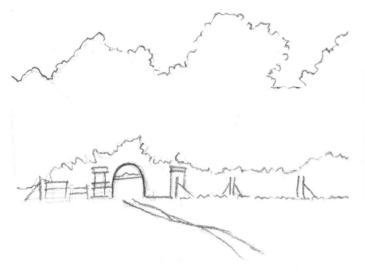

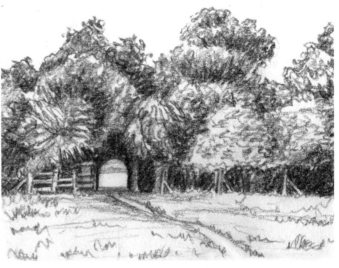

CLARITY

Although it's not too hard to read the basic elements of this scene, much of it is quite ambiguous.

A tonal rendering makes it much easier to read the image and separates the individual forms within the mass of foliage.

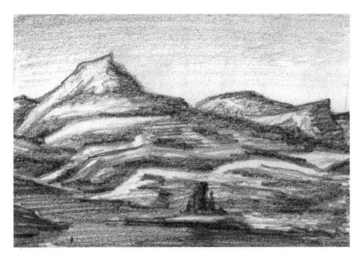

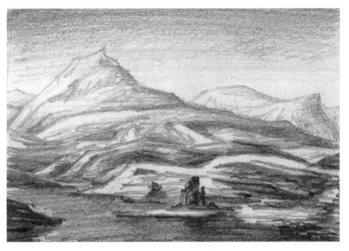

PICTORIAL DEPTH

This is clearly a mountain range, but with marks of the same weight throughout, the scene is strangely compressed.

Progressively fainter marks towards the background create the illusion of depth. To see a distant object, you must look through a greater mass of air than when you look at something nearby. This phenomenon, known as 'aerial perspective', has the effect of reducing tonal contrasts over distance. It's a very important principle in drawing landscape.

A STUDY IN TONE AND TEXTURE

There's a lot to keep in mind for even a simple landscape sketch, so don't be too ambitious with your first attempts. Find a subject similar to mine, in a garden, park or countryside, and take your time, working through the stages. I spent about an hour on this study and used a 4B pencil in an A4 sketchbook.

Step 1
The first step is to draw the general masses of form. I wanted to isolate each separate trunk and root and indicate the directions of their twists. You may prefer to use a harder pencil, such as an HB, for this stage.

HANDY HINT
Don't worry too much over the early stages. If organic forms are not drawn precisely it will not show. Accurate proportions are less important than capturing the essential flavour of the subject.

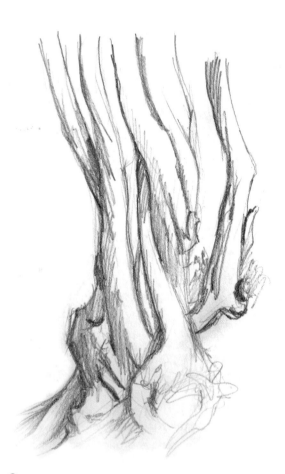

Step 2
Here I looked at the fall of light and roughly shaded each trunk to bring out its roundness and make it stand out clearly from the others.

Step 3

This stage is about texture, using varied marks to describe the coarseness of the bark and adding some knots, knobs and nodules along the way. The textural marks also refine the tone and add depth and solidity to the drawing. As a sketch I could almost have finished at this stage, but I was having too much fun to stop.

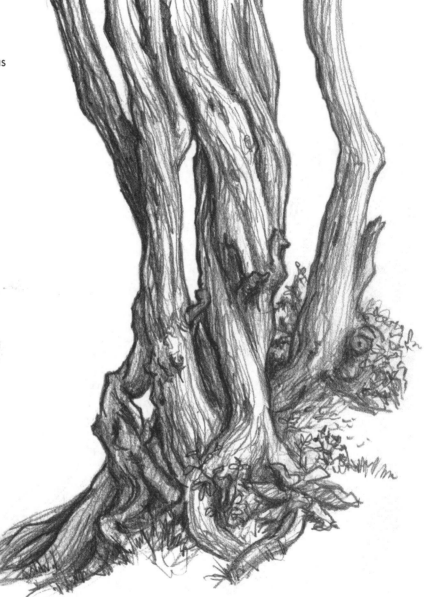

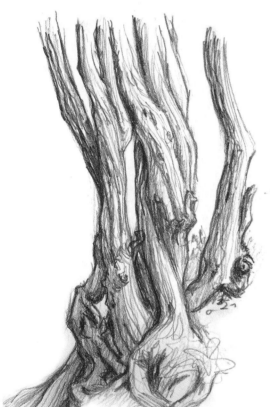

HANDY HINT

Squinting your eyes is a really effective way to judge tone on your subjects and spot inconsistencies in your drawing.

Step 4

Some suggestions of grass and weeds around the base of the tree help to root it to the ground and make for a more complete study. Then it was a case of reviewing the tones across the whole image and strengthening them where necessary.

SKETCHING PRACTICE

Before tackling expansive landscape scenes, it is well worth spending some time sharpening your sketching skills on smaller details. Make dozens of little sketches of many different objects, surfaces and plant forms, following the principles outlined on the previous pages. This will very quickly develop your facilities for observing organic forms and mark making. It is also a gentle introduction to the rigours (and pleasures) of working out in the wild.

HANDY HINT

Sitting still outdoors you can get quite cold, so wrap up warm and maybe take a collapsible stool to keep you off the damp ground. If it's very sunny, a wide-brimmed hat will shield your face from the sun and save you from having to wear sunglasses.

I have worked in sketchbooks from A6 (10 x 14cm / 4 x 5½ in) up to A1 (60 x 84cm / 24 x 33in) but I generally use the more practical A4 or A3 sizes.

HANDY HINT

Think of your sketchbook as a personal journal that nobody else ever need see, a space to make errors and false starts and to chart your artistic development.

19

A LANDSCAPE SKETCH

For a first foray into drawing a broader scene, find a location that is reasonably limited in layers of pictorial depth and conflicting textures. Make yourself comfortable enough to sit for an hour or so. Following the stages outlined here, you should find your drawing comes together quite quickly. Don't be too ambitious yet; keep the scale manageable (A4 or A3) and don't worry about any fiddly detail.

Step 1
Always start by establishing the broad masses with confident strokes. An HB pencil is probably best for this stage.

Step 2
Happy with my basic layout, I looked more carefully at the scene and refined the drawing to establish firm guidelines.

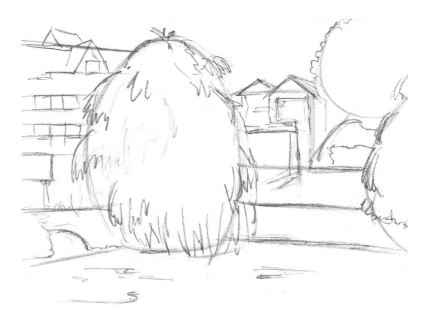

Step 3
Switching to a soft pencil (4B), my initial shading was deliberately unfussy, roughing in all the main areas of shade with the same motion. The point here was to cover a lot of the white paper quickly, which moves the drawing along rapidly.

HANDY HINT
In black and white artwork, it is a widely used convention to play down local tone and allow the brightest parts of a subject to remain white. This makes for bold, clearly readable drawings.

Step 4

Next I made a closer analysis of the tones, applying heavier shading where it was needed and stating some of the details along the way. I adjusted the direction of the pencil strokes to suit the surfaces I was trying to describe.

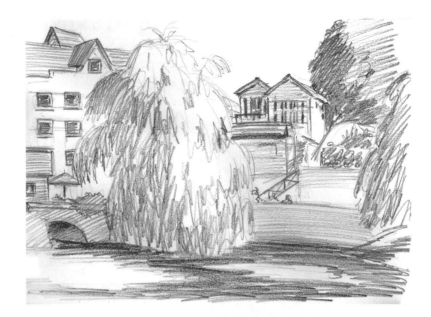

Step 5

Working over the whole drawing, I honed the details, squinting my eyes to discern the tones. A few minimal bits of erasing were all that was needed to clean up and finish off, as most of the underdrawing was lost amid the shading.

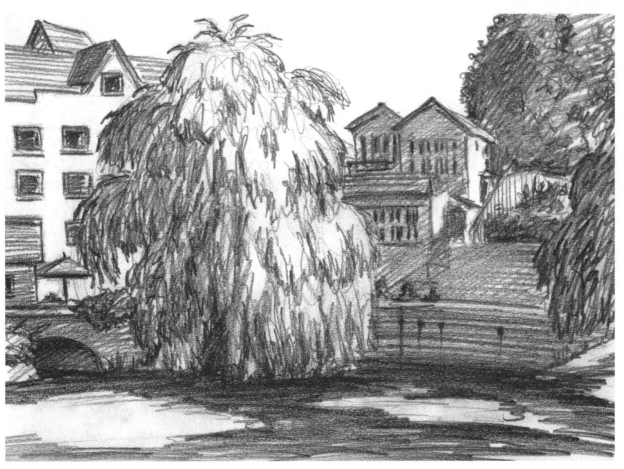

SKETCHING AIDS

CHECKING DIMENSIONS

When sketching from a landscape, the proportions of features at different distances from your viewpoint can be confusing and difficult to judge by eye. A simple technique, known as 'sight-sizing', will help you to quickly check the dimensions within a scene. Holding your arm *locked* straight out in front of you, measure the length of an object as it appears along your pencil and mark the length with your thumb. That measurement can then be used to check against other dimensions. In this diagram, you can see that the distant stones register the same dimension in height as the foreground stones do in breadth.

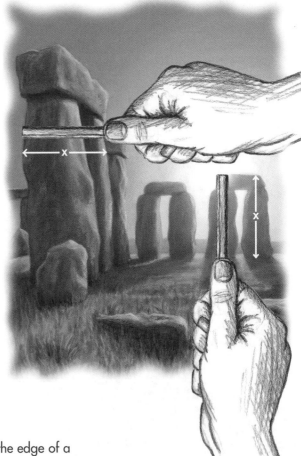

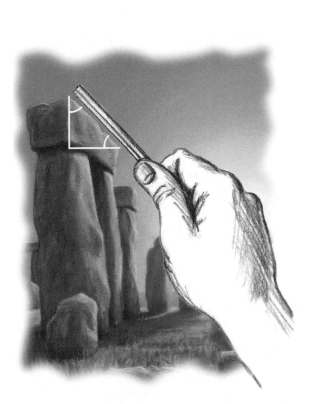

CHECKING ANGLES

Drawing landscape scenes often involves sloping lines, such as the edge of a mountain, the slope of a rooftop or the recession of a road or river into the distance. Accurately assessing the angles of such lines is important in drawing the scene convincingly. Again, the pencil can be used as an aid. Hold your pencil vertically about 30cm (12in) in front of your eyes then tilt it left or right until it lines up with the angle you wish to draw. Holding that angle, move the pencil down to the relevant area of your drawing.

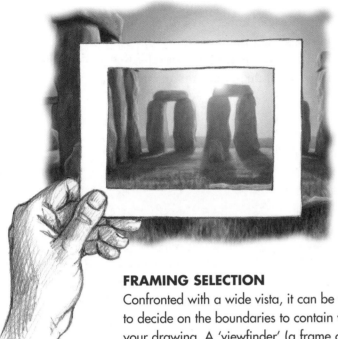

FRAMING SELECTION

Confronted with a wide vista, it can be tricky to decide on the boundaries to contain within your drawing. A 'viewfinder' (a frame cut from cardboard) will help you to select a composition and see how it will fit within your picture area. Move the viewfinder in and out to take in more or less of the scene. See how it looks upright (portrait format) or lengthways (landscape format).

When you have decided on a composition, try to fill the page as fully as possible, giving yourself plenty of space for bold lines and expressive mark making. Working small restricts your movements and tends to produce overly fussy pictures.

POINTS OF VIEW

As you wander through the landscape, you will, of course, notice that the scenery alters in relation to your point of view. It is one of the great benefits of drawing from life, rather than copying photographs, that you can shift your position to find the viewpoint that interests you most.

THE HORIZON

As well as affecting the compositional balance of a picture, the horizon also gives the pictorial elements of a landscape a sense of height and placement. A flat horizon is always perfectly level with the artist's eye-line. To demonstrate, I made the following sketches at different levels down a crumbling cliff.

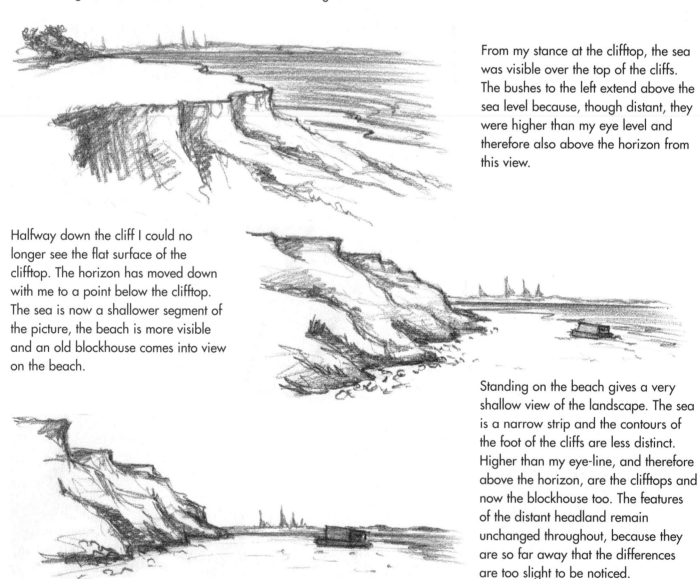

From my stance at the clifftop, the sea was visible over the top of the cliffs. The bushes to the left extend above the sea level because, though distant, they were higher than my eye level and therefore also above the horizon from this view.

Halfway down the cliff I could no longer see the flat surface of the clifftop. The horizon has moved down with me to a point below the clifftop. The sea is now a shallower segment of the picture, the beach is more visible and an old blockhouse comes into view on the beach.

Standing on the beach gives a very shallow view of the landscape. The sea is a narrow strip and the contours of the foot of the cliffs are less distinct. Higher than my eye-line, and therefore above the horizon, are the clifftops and now the blockhouse too. The features of the distant headland remain unchanged throughout, because they are so far away that the differences are too slight to be noticed.

PERSPECTIVE

Many of the geometric rules that govern the appearance of three-dimensional objects over distance are quite complicated. But seeing as most landscape drawing is based on imprecise organic form, you need only learn a few of the basic principles.

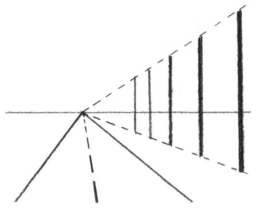

Objects receding into the distance do so at a constant rate. In this diagram (left), the edges of a road converge at a point on the horizon, known as the 'vanishing point'. Guidelines show that the tops and bottoms of a row of parallel posts can also be plotted to recede to the vanishing point.

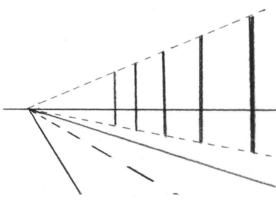

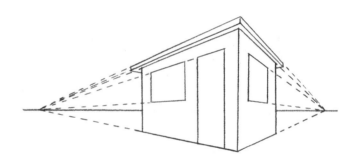

With the point of view shifted to the left, the vanishing point moves and so do the receding lines. Note that the vertical lines remain strictly vertical throughout. Only when looking up or down at an exaggerated angle do vertical lines ever appear to tilt.

When you can see two sides of a building, as in the drawing above, there are two vanishing points to consider.

Perspective also applies to the organic forms of nature. These lines, though slightly curved, recede to a common vanishing point. Such formations are clearly observable in bands of cloud. Below the horizon, the same formation can be seen in the furrows of a ploughed field or waves on the sea.

Seen from the side, the recession may not be so dramatic, but there is still perspective at work. Bands of cloud are very much narrower and closer together than they are overhead. Again this principle applies in reverse below the horizon.

PERSPECTIVE SKETCHES

A very basic grasp of perspective should be enough to bring order to the landscape and, through the process of drawing varied scenes, the principles should soon become instinctive. Sketching these two very different scenes involved little more than a casual reflection on the perspective at work. In each case, I was more occupied with textures, lighting and energetic mark making.

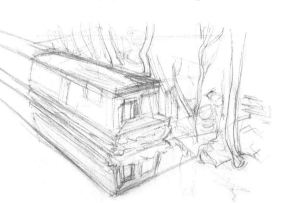

Step 1
Here I added receding lines to show the perspective involved. In practice, I would judge these angles by eye with the pencil (see page 22). Note how the perspective of the barge's shadow runs to the same vanishing point, as if an identical barge is glued to the underside.

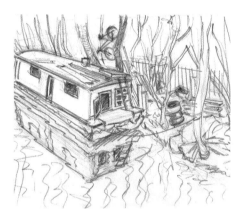

Step 2
In firming up the outlines, my lines were scratchy and carefree. I kept the marks for the barge, trees, reflections and debris distinct from each other. Being parallel to the barge, the railings ran to the same vanishing point.

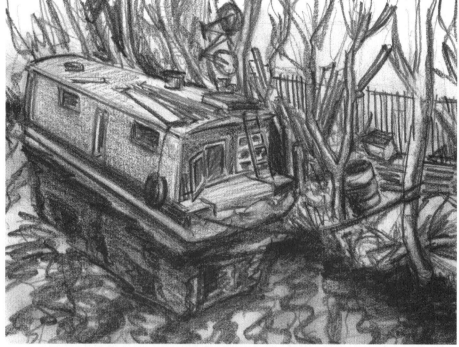

Step 3
With a heavy graphite stick (see page 32), I enjoyed pushing tone around, smudging and virtually attacking the paper. When working with heavy tone it is important to keep the picture legible, even if you have to invent outlines, highlights or areas of deep tone for details to stand out against.

Step 1

Once I had established the horizon, I marked the rough outline of the lane and wall, all converging at the same approximate vanishing point. Then I roughed in the main masses and started to work on the outlines.

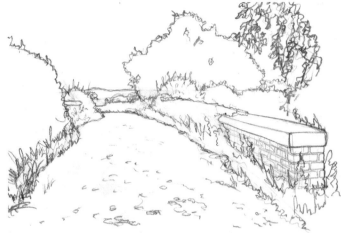

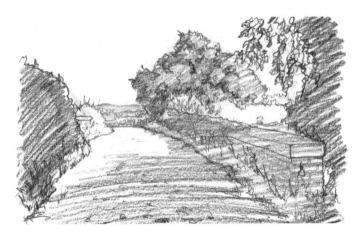

Step 2

Working up the detail, I paid particular attention to the end of the lane, to show it curving around a distant corner.

Step 3

I scribbled in the rough areas of shade in no time, conscious of the patches of bright sunshine in the middle distance.

Step 4

In refining the tones, I used a range of marks to suggest the different textures. Not forgetting aerial perspective, I started with faint marks from the most distant features and worked towards the foreground, reserving the darkest tones for the nearest objects. For clarity, I left the patches of sunlight white. Landscape drawing very often involves managing a balance between lighting and local tone.

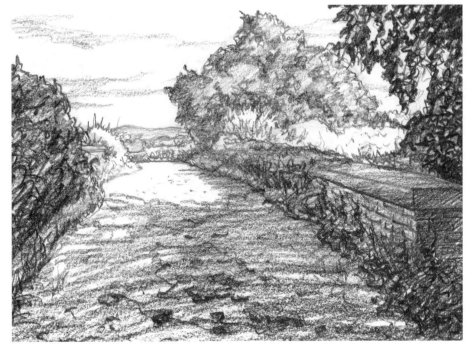

THE BIG PICTURE

When you approach making a full-scale landscape drawing there are a great many things to juggle. At first, the complexity of a large scene might be quite daunting, but some basic rules and hints, many of which we've touched on already, should make the subject easier to confront.

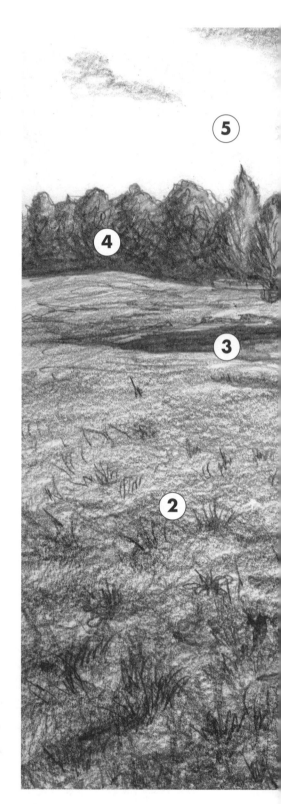

1 Reserve the richest tones and greatest tonal contrasts for elements in the foreground.

2 For larger featureless areas, find a texture to break up the monotony of the mass. The texture, like the tone, should get bolder towards the viewer.

3 Water is usually dark where it meets the land.

4 Distant objects appear progressively weaker in tonal contrast, relative to those close up: the effect of aerial perspective.

5 Try to leave the pure white of the paper for some areas of the drawing.

6 A clear sky gets progressively paler towards the horizon.

7 Reflections run directly vertical from source objects.

8 A focal point should not be rendered in significantly greater detail than its surroundings.

9 The quality of the marks you use help describe the character of trees and foliage.

10 Some simple silhouetting can be effective.

11 Long grass should be treated with different marks to short grass.

12 Reflections are at least as dark and normally darker than source objects, but diminish in intensity with steep angles of view to the reflective surface.

13 Reflections of sky are darker further down from the horizon.

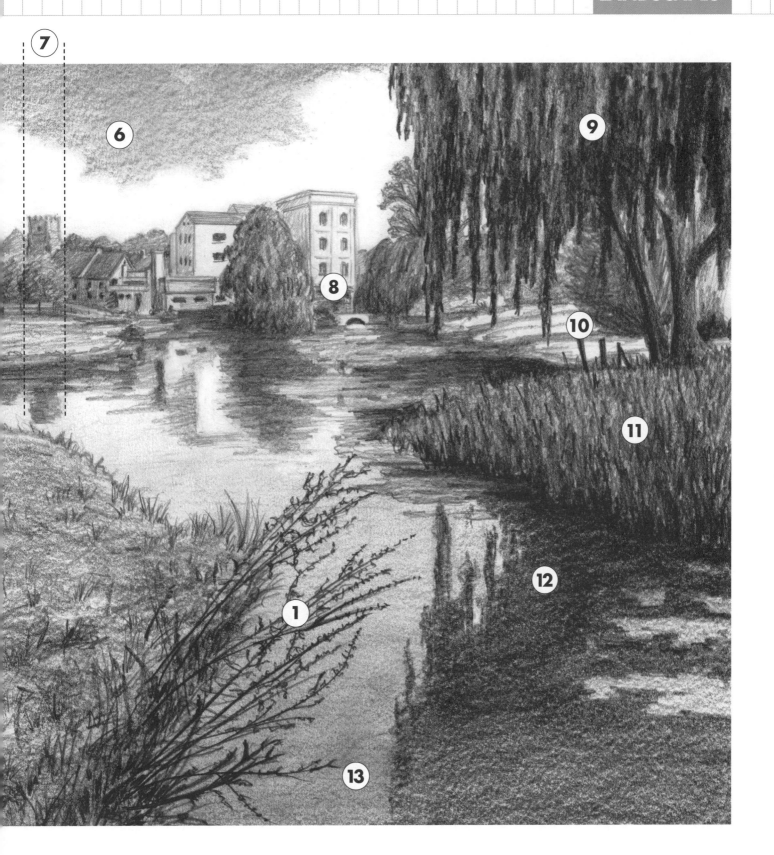

COMPOSITION AND SELECTION

The arrangement of elements within the picture area is one of the most crucial considerations for successful landscape art. Look at lots of landscape paintings and photographs in books or galleries and try to work out why some have more impact or grace than others – it usually comes down to composition. The following croppings demonstrate some of the elementary compositional 'rules'. When you settle down to draw, consider different compositional possibilities before you commit a scene to paper.

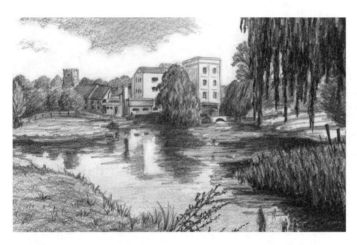

This is dull. Setting the horizon and main feature in the middle of the picture guarantees a boring composition. Broad masses of dark tone are clumped on one side, upsetting the tonal balance.

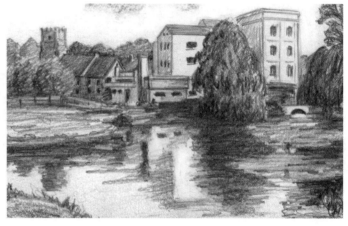

This selection zooms closer in on the buildings yet allows space for their reflections to play an active part in the composition. The higher horizon makes for a more decisive and effective use of space.

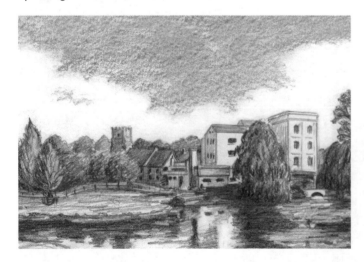

With a lower horizon, the water is largely cropped off and the sky is allowed enough space to feature strongly.

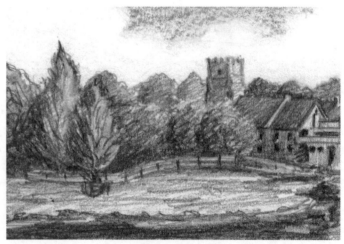

There's nothing to say you have to draw the dominant feature of a scene. You are free to select whatever interests you.

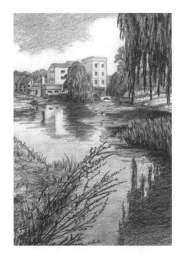

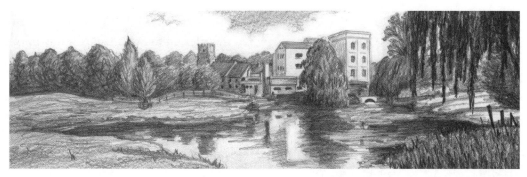

An extreme horizontal format is similarly effective, lending the scene a cinematic quality.

This more extreme vertical framing (below) reduces the scene to three layers of depth. Excluding peripheral detail can give a picture intrigue and impact.

This portrait format enhances the meander of the river to reveal a pleasing 'S' shape curve. The cropping is carefully considered for tonal balance.

HANDY HINT

To compose different shaped pictures, two L-shaped cut-outs and some paperclips will make a viewfinder of any proportions.

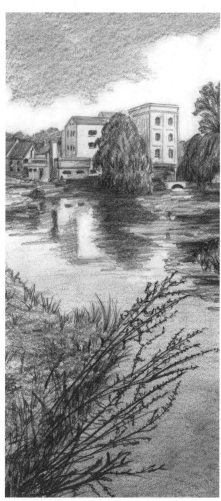

Here the sweep of the river leads the eye into the scene in a graceful curve. The darker tones bring a different feel to the picture.

MORE MATERIALS

Versatile though the pencil is, there are more mark making possibilities to be explored in different materials. The following examples are all, to varying degrees, suitable for sketching outdoors. Each has its particular strengths and limitations. The best way to learn about them is to experiment for yourself, to find out what works for you and what suits certain subjects and moods.

By now, you will probably have come to recognize a natural style developing in your drawings. When expanding your range of materials, try to retain something of your characteristic way of working.

Watercolour

I shaded this tree in a couple of tones of black watercolour wash. It is not the most practical medium for sketching outdoors, requiring water, brushes, a palette and drying time, but is popular for the blending and textural effects that can be achieved.

Graphite stick

This is a stick of pure, soft graphite, so it's essentially just a very thick pencil. But being so much chunkier, it feels different in the hand, covers the paper quickly and encourages bold handling.

Water-soluble pencil

This is one of my favourite sketching tools. It handles exactly like a normal pencil, but it also gives you further options. Applying water to the drawing, with a brush or fingertip, dissolves the pigment and allows you to soften edges and push the pigment around like thin washes of paint. For black and white sketches it is an ideal substitute for watercolour.

Felt-tipped pen

Using ink encourages you to be positive in your mark making. There are no shades of grey and the mid-tones are built up from textural marks and hatching. Good-quality felt-tipped drawing pens are inexpensive and handy to use in the field. They can be used on their own or to define detail in other media.

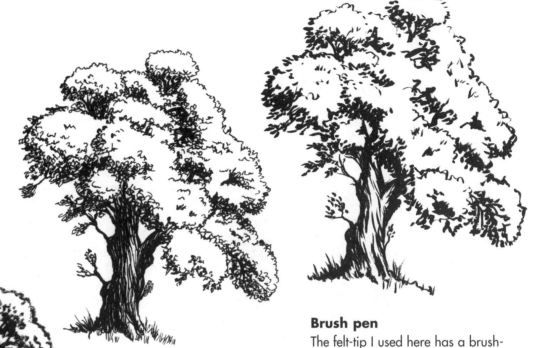

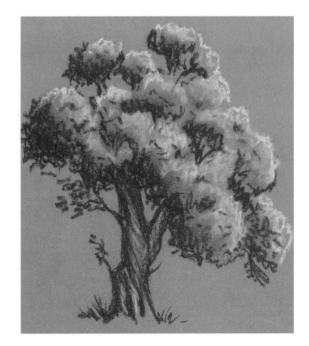

Brush pen

The felt-tip I used here has a brush-shaped nib, allowing for broad, varied marks and fine detail. A brush pen provides a portable way to draw with brush and ink.

Charcoal

Charcoal, with its dark line, encourages boldness, though it can easily be softened or corrected. The smudginess that makes charcoal so versatile also means that it is unstable. Finished charcoal and chalk drawings can be protected against smudging with an artists' fixative spray, although hair spray is nearly as good and much cheaper.

Pastels/ toned paper

Pastels are very much like charcoal, but come in a vast range of tones and colours, which may be smudged and blended in many ways. Being opaque, light tones can be laid on top of dark ones and they work especially well on toned or coloured paper.

STRIVING FOR SIMPLICITY

Beyond the pencil, new materials open you up to a bewildering array of tonal and textural possibilities, so much so that there's a danger of allowing the medium to overwhelm the message. But different materials can also be thought of as means to bring boldness and simplicity to your drawing. Important lessons may be learned from paring down a subject to its bare tonal essence, lessons that will inform your work in all media.

Brush and ink

Rendered in plain black ink with a medium watercolour brush, this row of neatly pollarded willows has a bold, illustrative feel. With no shading or mid-tones, you are forced to make stark decisions between either black or white for each part of the picture, whilst maintaining clarity of design. I added the distant bridge with white ink.

Scraperboard

A scraperboard is a white card with a thin covering of solid black. You draw with a sharpened tool to reveal the white. The process of drawing light into dark is more than an interesting novelty; it is a principle that can be used with many different materials for textural effects that would be very hard to achieve otherwise.

A LANDSCAPE IN RESTRICTED TONES

This is a slightly more sophisticated exercise in observing tones. I have used felt-tip marker pens, but you could use pastels, poster paint, watercolour, coloured pencils or any medium that comes in definite shades of grey. By restricting yourself to three or four flat tones you will learn to see the landscape in the simplified tonal values that may very well help you to avoid overworking future pictures.

Step 1
Without any pencil underdrawing, I used my palest tone to roughly fill in all the appropriate areas, being careful to preserve the pure white paper for the lightest areas.

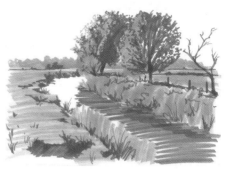

Step 2
Switching to my medium tone, I filled in the darker areas, varying the textural marks where necessary. Already the scene is clearly readable.

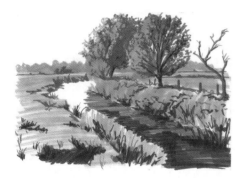

Step 3
I used the darkest tone quite sparingly to give the picture depth and to work in a bit more texture.

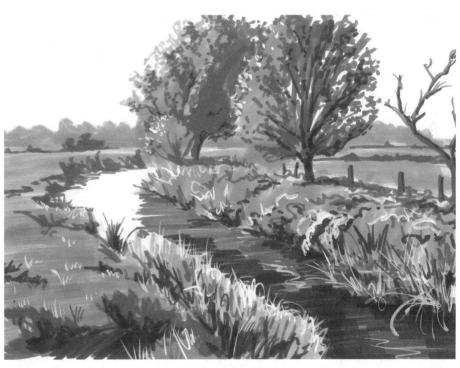

Step 4
For some final touches I picked out some details in white ink, working quickly and haphazardly to retain the picture's loose treatment.

HANDY HINT

A small bottle of white drawing ink and a fine pointed watercolour brush are very useful additions to your kit. They can be used for all sorts of highlights and textures and are also handy for correcting mistakes. Make sure you stir the ink well before every use.

A LANDSCAPE IN PEN AND WASH

Different materials, as you will discover, have various strengths and weaknesses, and some lend themselves better to certain subjects than others. They may also be used in conjunction with each other to make best use of their respective qualities. A classic combination is pen and wash, in which the pen pins down firm outlines and the watercolour wash quickly covers broad areas of tone. Make sure you use waterproof ink and heavyweight paper.

Step 1
I made sure the basic shapes of my pencil guidelines were fairly accurate before working with the permanent ink of the pen.

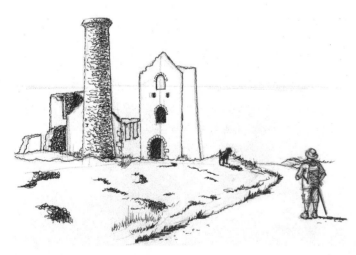

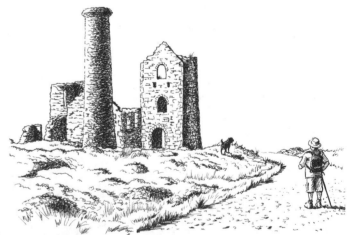

Step 2
With a fine felt-tipped drawing pen (0.5mm), I carefully retraced the outlines and started to add shade in textural marks. During this stage a rambler came by, so I quickly drew him and his dog to give the scene some depth and scale.

Step 3
Having finished all the texture and shade, I could erase my pencil guidelines. The drawing is nearly complete and it only remains to use the watercolour to add broad washes of tone.

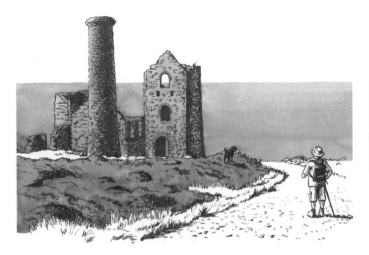

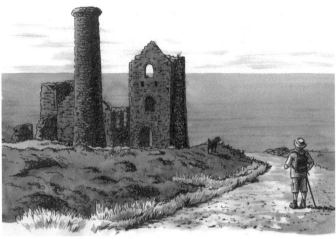

Step 4

I mixed up plenty of very thin black watercolour in an old saucer and used a broad brush to wash over the sea and buildings in one go. It's important to do this quickly to avoid streaks. With a darker tone I covered the scrub in the foreground and set the drawing aside to dry.

Step 5

Some more touches of watercolour quickly strengthened the tones and added some detail here and there. Some subtle strokes give texture to the sea and suggest the distant clouds.

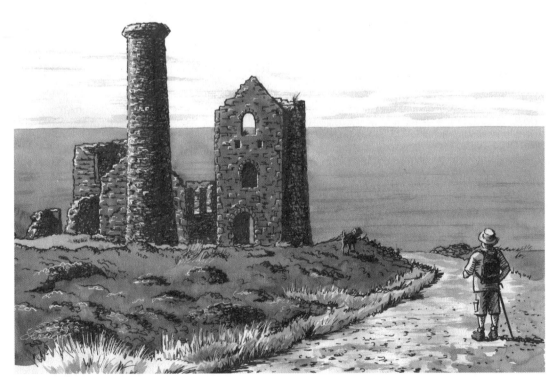

Step 6

At this stage the sun was about to move behind the front face of the stonework, so I worked very speedily to capture the glancing highlights before they disappeared. I used white ink with an old-fashioned dip pen, which was also useful for lifting out some grass and highlights in the foreground.

A LANDSCAPE IN CHALK AND CHARCOAL

To complement the bleakness of this atmospheric scene, I worked on grey paper. Other than the pencil underdrawing, I used only charcoal and a cheap piece of children's blackboard chalk. The composition is classically proportioned with the horizon about a third of the way down the picture and the focal point (an old lighthouse) about a third of the way in from the side. Controlling the aerial perspective was important to the atmosphere, so I worked generally from the far distance towards the foreground, strengthening tones along the way.

Step 1
I kept the rough pencil drawing very simple. Using the side of a short length of white chalk, I laid on the basic tone of the sky. I smudged and blended the sky tone with my fingertip to produce a fairly smooth gradient, then drew the clouds on top with more white chalk. These radiate from a vanishing point to the right of the picture.

Step 2
I applied the first strokes of charcoal, taking care not to press too hard. Subtlety is everything with an atmospheric picture and it's easier to strengthen tones later than it is to weaken them.

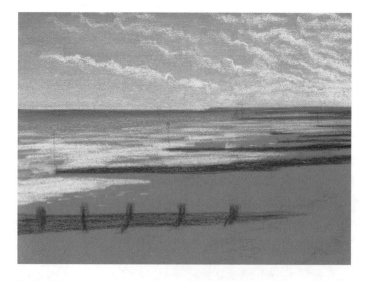

Step 3
I added the white of the water around the groynes where it reflected the light of the sky. I also smudged the charcoal of the sea for a smooth transition towards the horizon.

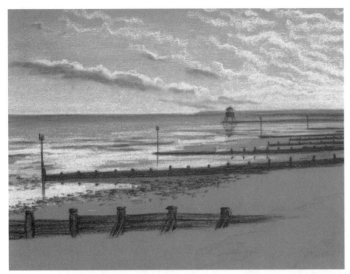

Step 4

With the highlights of the water in place I could properly establish the charcoal drawing and control the tones. Smudges of charcoal in the bigger clouds gives them solidity. Happy with the general background, I added the detail of the posts and lighthouse as well as their reflections.

Step 5

Here I strengthened the tones of the seaweed in the foreground to bring it forward in the picture and added a few bright highlights. Aerial perspective is not simply about the darkness or lightness of things, but their relative contrast.

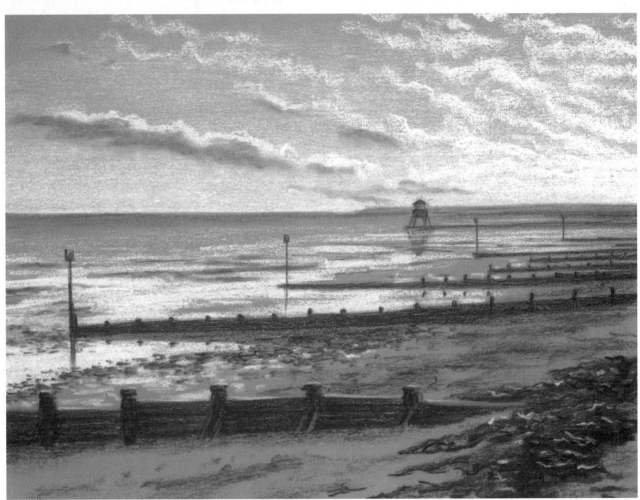

A LANDSCAPE IN PASTELS

Inspiration often strikes at inconvenient times and you may spot great subjects when you are busy or without materials. As long as you can jot down the essentials of a scene, you can work it up into a picture later. The great thing about landscapes is that once you are conversant with natural forms, textures and lighting, you can make up those details that circumstances prevent you from recording accurately.

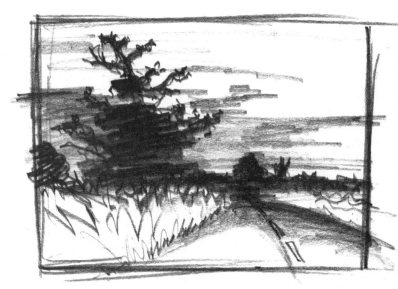

Driving in the late summer evening, I was struck by the silhouette of a dead tree and the verges illuminated by my headlights. I stopped the car, drew this rapid sketch and tried to commit as much detail as possible to memory. Once home I set about the pastel study shown on these pages, which took about an hour.

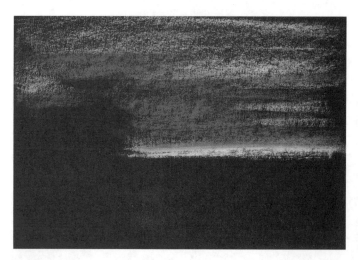

Step 1
On some cheap, black craft paper I applied some sky tones in horizontal strokes using the sides of short sticks of white and grey pastel.

Step 2
I smudged the pastels with a fingertip, then added more layers of pastel to build up a smoothly blended night sky.

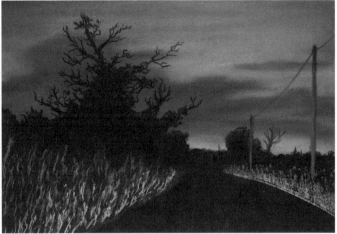

Step 3
On top of the sky I added the next layer of the picture with charcoal, largely inventing the details of the branches and the skyline.

Step 4
Using artistic licence, I added some telegraph poles to lead the eye into the picture, and then mapped out the areas of illuminated grasses.

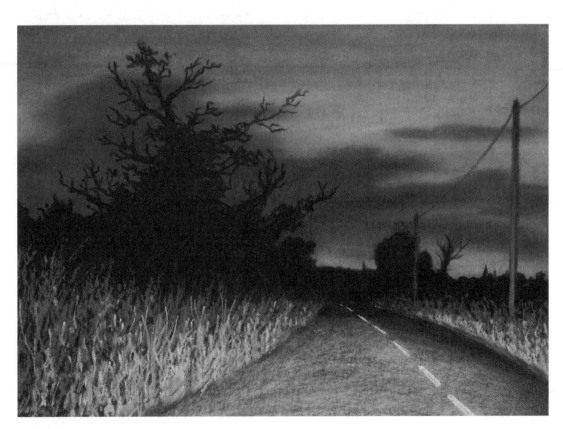

Step 5
I worked on the details and mass of the verges in grey pastel and then in white on top for an extra layer of depth. The road surface was stroked on with the side of the white pastel stick and smoothed over with my finger. I added the white lines and some highlight on the nearest telegraph pole.

CREATIVE FREEDOM

Up until now, the landscapes that we have worked on have been drawn from directly observable locations. As you have seen, it is important to consider your selection of subject, viewpoint and framing to bring the best out of a view. With the last example though, I worked from a mere impression of the scene and effectively invented the details. As an artist you are free to interpret your subject material in any way you choose. Ultimately, a picture is judged on its own terms, independent of the scene that inspired it.

Landscape forms lend themselves well to strong, simple designs, which can be based on observed scenes or conjured from the imagination. Try to create some of your own as exercises in simplification and composition.

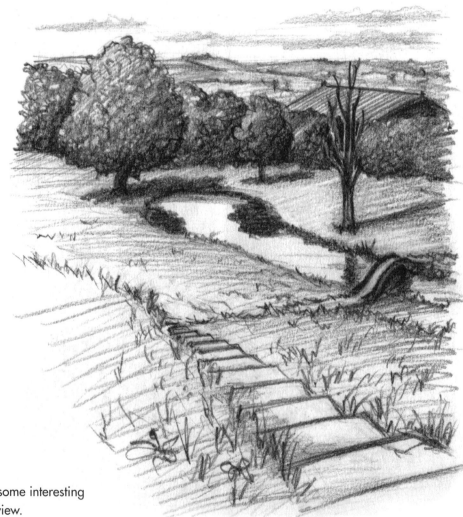

SCENE 1
I drew the above scene from life. Despite some interesting elements, it is not a particularly pleasing view.

42

SCENE 2

Here is a reworking of the scene, done at home. When you make such changes, remember to adjust shadows and reflections as appropriate. In practice it's unlikely that you would want to change so many elements – if it's that unsatisfactory, you would do better to look elsewhere for inspiration! My changes are merely a demonstration of the kinds of creative alterations that can be made.

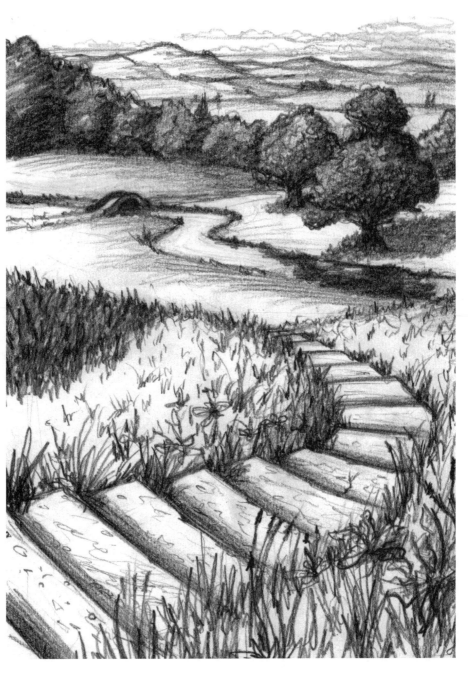

Line of trees varied

Tree removed

Bridge moved to more prominent focal point

Shadow added to balance the tones in the composition

Steps enlarged and curved to lead the eye gracefully into the picture

Height of hills exaggerated

Barn removed

Tree restored to life

Odd-shaped lake changed to a meandering river

Strong plant forms in foreground for pictorial depth

INVENTED LANDSCAPE – WATER-SOLUBLE PENCIL

Once you accept the idea that you are not obliged to depict scenes as they look in reality, landscape offers particular scope for the imagination. The imprecise organic forms of the natural world lend themselves perfectly to creative composition. When you have put in the groundwork, learning to draw real landscape features, you can re-interpret those forms again and again in pictures of ideal charm, brooding atmosphere or pure fantasy.

On scrap paper, I jotted lots of small trial compositions. I was looking for a scene that had layers of depth and a clear route through the picture. This is the one I liked best.

Step 1
With a soft, water-soluble pencil (6B), I sketched the main forms, without going into detail. I also applied a rough tone across the sky, darker at the top and paler at the horizon.

Step 2
Using a broad, soft brush loaded with clean water, I washed across the whole sky and distant land masses. Some of the foreground drawing was lost in the process, but it's more important to make the sky smooth and even than to try painting around things.

Step 3
After re-stating the lost drawing, I used a fine watercolour brush to wet the distant masses, one plane at a time, pushing the pigment around with the brush until I was satisfied.

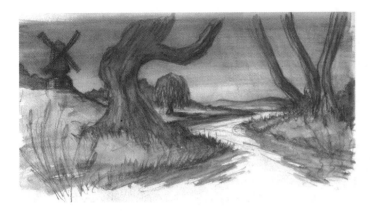 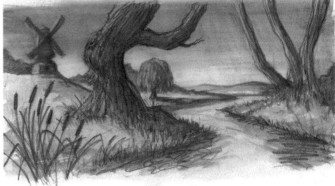

Step 4

Then I continued the same process across the foreground planes, using a larger brush. As the shapes get larger, mark making becomes more important. The brush picks up enough pigment to make textural stokes.

Step 5

Once everything was dry, I pulled out some highlights with the point of an eraser. I then used the pencil again to deepen tones where necessary and draw more detail.

Step 6

I did some more brush work to integrate the new pencil marks and then, with pencil and fine brush, I added some more bits of detail here and there. To bring out brighter, sharper highlights, I used white ink with the fine brush. Framing off the picture tightened the composition and finished my imaginary landscape.

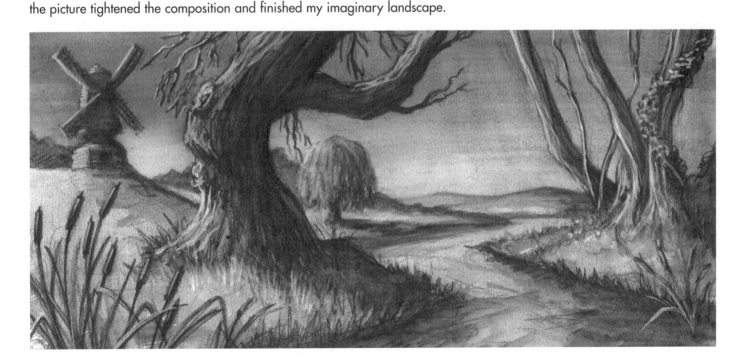

INVENTED LANDSCAPE – DILUTED INK

Sometimes the most rewarding artwork comes without any planning at all. A different approach to drawing with a brush is to paint masses and forms directly, without any prior pencil work. It isn't always successful, but the process is quick enough that failed attempts do not matter. For these demonstrations I used fountain pen ink on heavy cartridge paper.

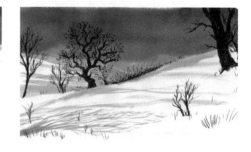

Step 1

Before I started, all I had decided was to do a snowy scene at night-time. I mixed up some ink and water in a saucer and used a large, soft brush to paint across the top third of my paper. Whilst the ink was wet, I added a deeper tone in places and let the ink settle arbitrarily.

Step 2

With a thinner mix of ink, I then gave some form to the landscape, imagining the moonlight coming from the left. I also decided to paint the shadow of a tree across the foreground.

Step 3

Neat ink and a fine brush allowed me to draw some tree silhouettes where the landscape suggested them. A few blades of grass are always handy to suggest a covering of snow.

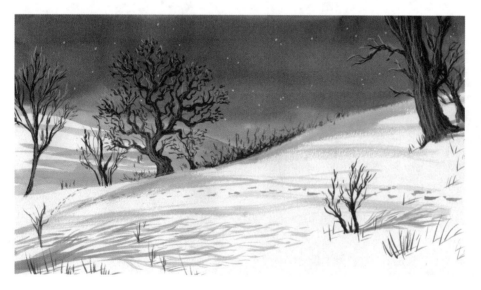

Step 4

To complete the scene, I painted the shadows of the undergrowth. I used white ink, slightly diluted, to add some texture and highlights on the trees. A few spots of neat white ink suggested stars in the night sky.

Step 1

To begin this example, I wet the entire surface and then swept diluted ink across it with a broad brush. I then added less dilute ink quite randomly and let it merge and pool. As it dried, I studied the surface to see what features it suggested.

Step 2

So as to avoid tightness, I stayed with the broad, flat brush and started drawing features on to the background, using ink at various strengths.

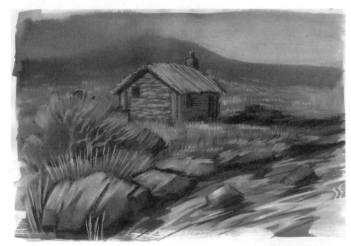

Step 3

Still with the broad brush, I then used diluted white ink to bring form and light to the picture. In three quick stages, this was almost finished, but it did need a few adjustments yet.

Step 4

Unhappy with the placement of the cottage within the curve of the hill, I used more dark ink to reshape the background. I then took a fine brush and white ink to add a few highlights and detail. I carefully considered the final framing to make a satisfying composition out of this imagined scene.

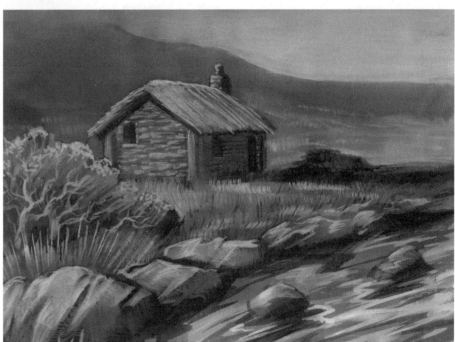

INDEX